Portraits *from Life*

by DAVID COLLIER

D0769911

DRAWN AND D&Q QUARTERLY

Also by David Collier:
Just The Facts (1998)
ISBN 1-896597-25-4

The stories in this book were originally published in the periodicals *Collier's* #'s 2, 3, and 4 (Fantagraphics Books), *Humphry Osmond*, and *Surviving Saskatoon* (Drawn & Quarterly).

ISBN 1-896597-35-1
First Printing: March 2001.
Printed in Canada.
10 9 8 7 6 5 4 3 2 1

Front cover colors by Bernie Mireault.
Publisher: Chris Oliveros

Drawn & Quarterly
Post Office Box 48056
Montreal, Quebec
Canada H2V 4S8

Free Catalogue available upon request.

Website: www.drawnandquarterly.com
E-mail: info@drawnandquarterly.com

FORWARD

I HAD already drawn the the first couple of pages of *The Ethel Catherwood Story* when I found out about her family. My source was an article in the old *Saskatoon Star* which invited the reader to "Meet the Parents of The Saskatoon Lily." It was a pre-Olympic puff piece, a profile of the athlete of the type that exists today as part of T.V.'s coverage of the games. I was just skimming this *Saskatoon Star* article until it mentioned that "the Catherwood family live at 408 25th Street West" in Saskatoon. Now *here's* something weird, I thought, I'm drawing a story set in 1928 about someone living at 408 25th Street West while I live at 407 26th Street West - Ethel Catherwood lived in that house directly behind my house ... maybe she high jumped in my backyard, I postulated. (The old triplex I lived in adjoined the largest unbroken expanse of green space for many blocks around). This coincidence gave a sorely needed boost to my confidence. I had never done a story like *The Ethel Catherwood Story* before and I took quite a bit of heat for even *attempting* it. "Why are you doing a story about a girl high jumper," I was asked, "who's going to be intrested in that?" After I found out about the coincidence, I was able to claim that some Higher Authority had intrests in me finishing the story.

I began *The Ethel Catherwood Story* immediately after I returned from skiing to Grey Owl's cabin in January, 1992. Everything - the style I drew comics in, my outlook on life - seemed to change after those three days in the snow. It was as though something in me broke during this this trip, but it was something that broke in me in a good way. It was as if some barrier in my lungs, that had always prevented me from breathing deeply, was gone. And who knows, maybe it was. A few years later when the story of my ski to Grey Owl's was happening, I worried that I was being irresponsible in the way I depicted my preparations for the trip. What if someone reads the comic and decides to ski to Grey Owl's cabin too? I fretted and worried about this, but I liked the plot device of a couch potato going through a huge physical undertaking too much in the end ... now, for the record though, I'd like to point out that by 1992 I'd done an awful lot of skiing. In 1990, when it became apparent that myself and the four other guys on my regiment's biathlon team were going to the National Finals with our cross-country skiing and shooting, the regiment's commanders were so pleased they ordered us to train full-time, just as our counterpart "amateur athletes" in the Soviet Army had been doing...

Out of a field of seventy-five at the National Finals my best finish was twenty-fifth - okay, not spectacular, only the top ten got to represent the country at The World Championships in Austria that year - but during the ski to Grey Owl's I wasn't some novice pissing around in the snow either.

Right now these words are late - I don't have time to thank Kelly Jennett and Tom McLachlan, who were on the Trail Crew at Prince Albert, or anyone else.

David Collier Hamilton, Canada
February, 2001

A Note on the Text: The last story in the book - two stories in one - can be read concurrently or at the same time.

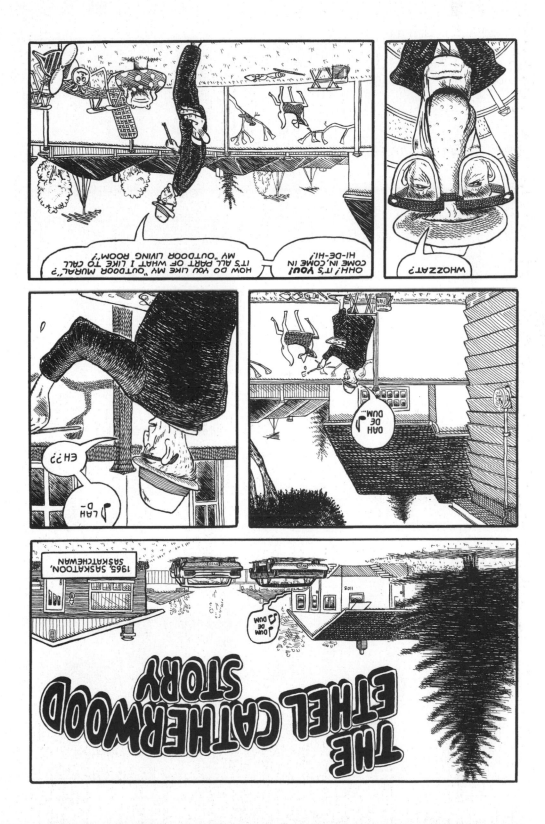

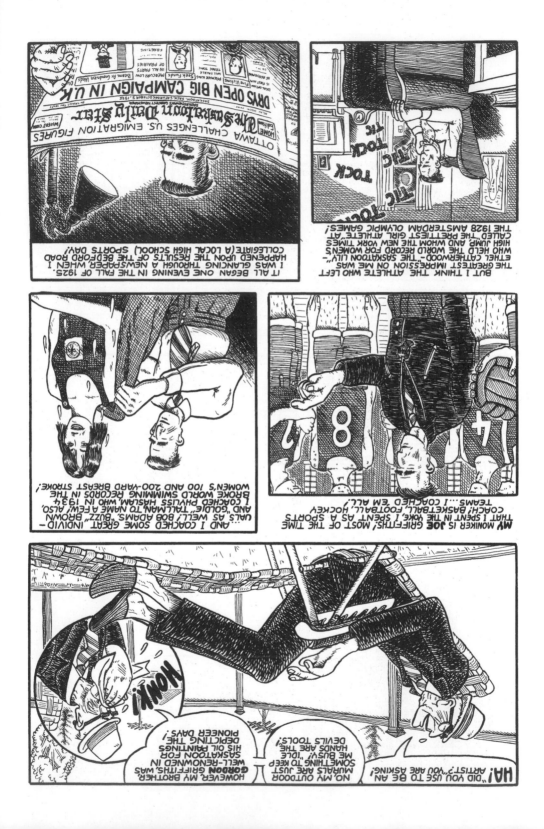

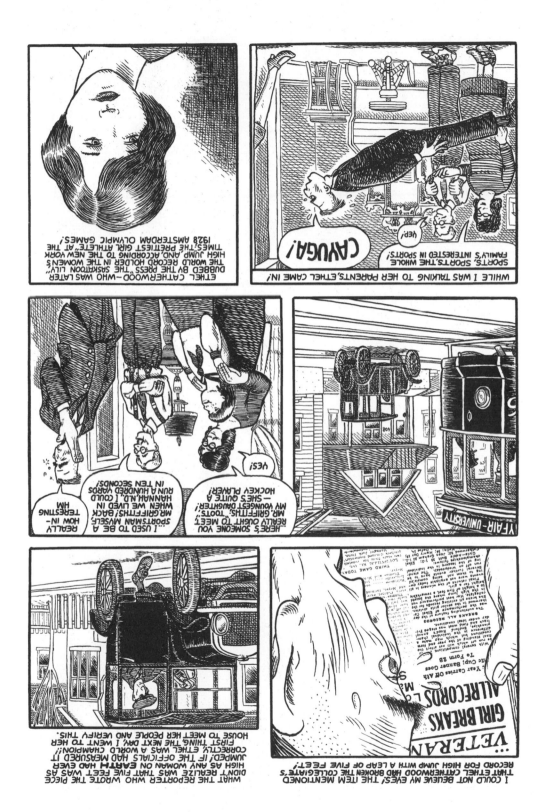

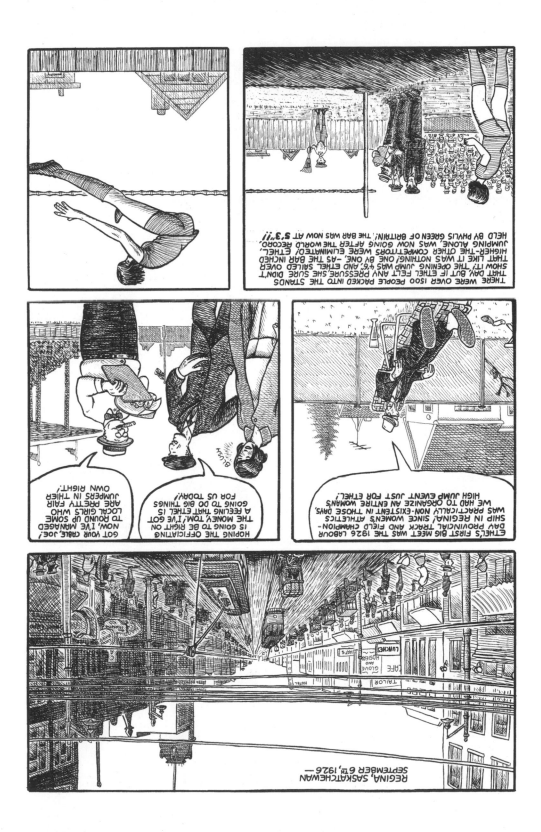

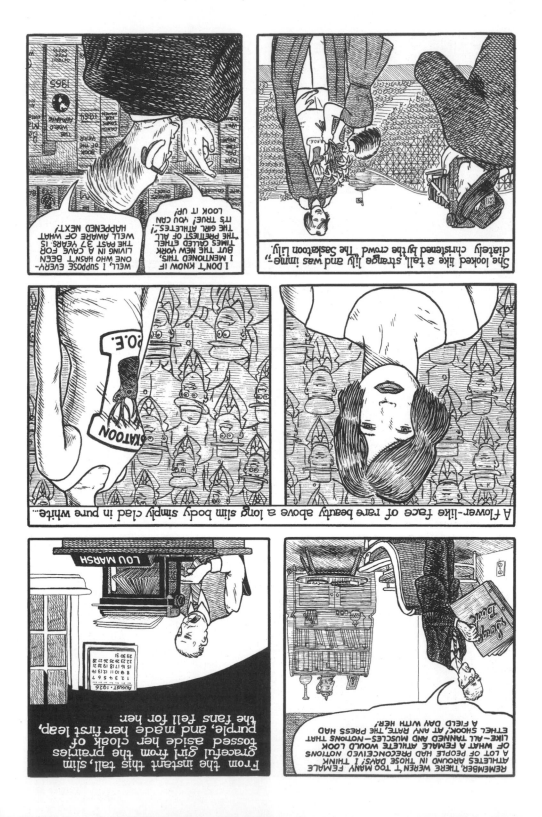

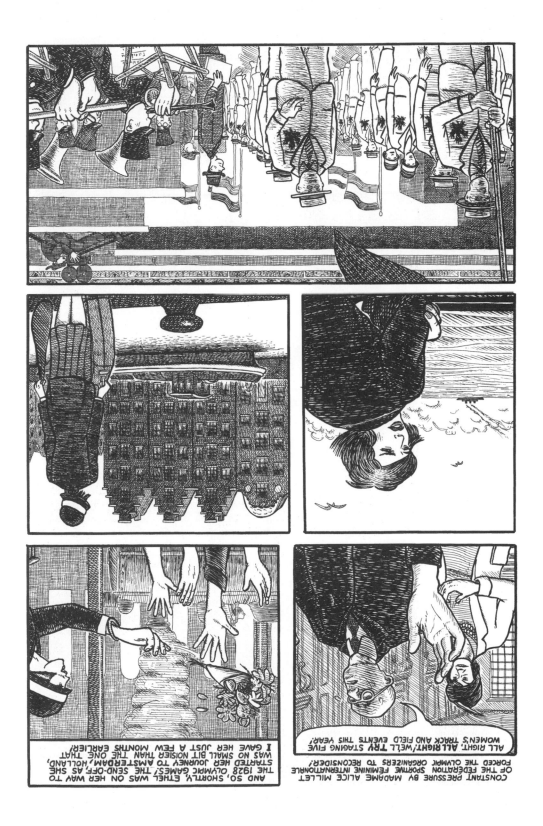

CONSTANT PRESSURE BY MADAME ALICE MILLET
OF THE FÉDÉRATION SPORTIVE FÉMININE INTERNATIONALE
FORCED THE OLYMPIC ORGANIZERS TO RECONSIDER!

ALL RIGHT, ALL RIGHT, WE'LL TRY STAGING FIVE
WOMEN'S TRACK AND FIELD EVENTS THIS YEAR!

AND SO, SHORTLY, ETHEL WAS ON HER WAY TO
THE 1928 OLYMPIC GAMES! THE SEND-OFF, AS SHE
STARTED HER JOURNEY TO AMSTERDAM, HOLLAND,
WAS NO SMALL BIT NOISIER THAN THE ONE THAT
I GAVE HER JUST A FEW MONTHS EARLIER!

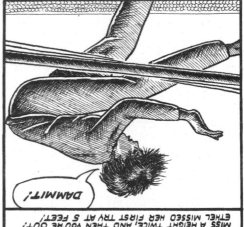
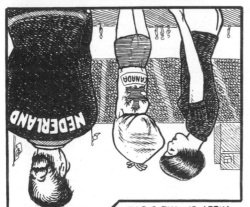

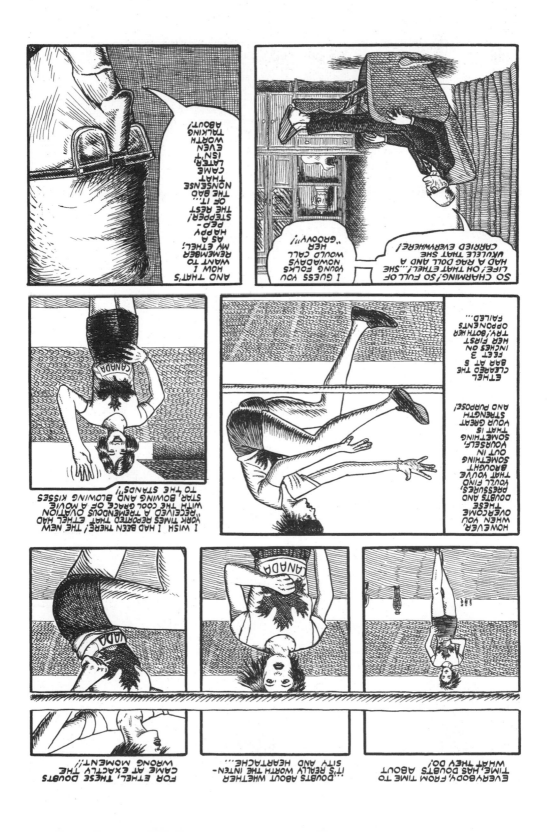

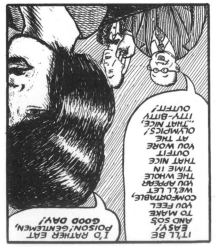
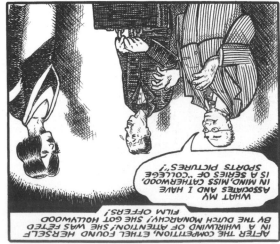

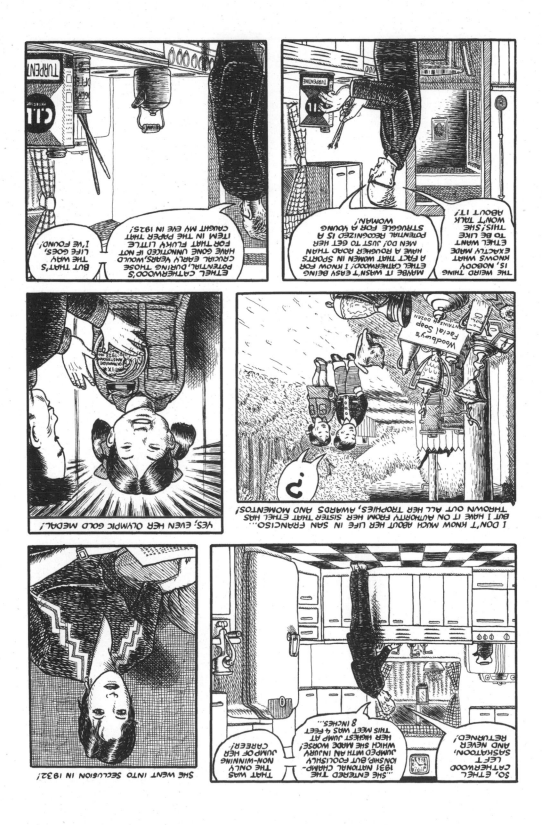

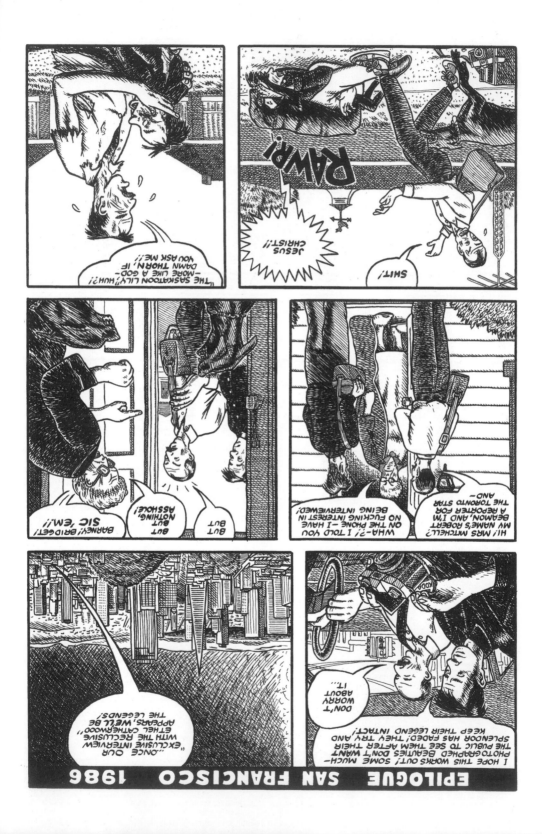

IT IS WINTER! A COLD, HARD, NORTH SASKATCHEWAN WINTER! YOU ARE STANDING ON A CREAKING, GROANING FROZEN LAKE! THE NEAREST HUMAN BEING IS AT LEAST FORTY MILES AWAY, YOU ARE THINKING TO YOURSELF, BUT YOU ARE NOT ALONE! SOMEWHERE, OUT ON THE ICE WITH YOU, IS A STARVING, DESPERATE PACK OF **WOLVES!** YES, EXISTENCE IS LOOKING PRETTY BLEAK RIGHT NOW, WHAT WITH THE WHITE HOT **PAIN** IN YOUR BACK, YOUR **HUNGER,** YOUR **EXHAUSTION...** IT IS PITCH BLACK OUT, AND YOU CAN'T SEE ANYTHING ON THIS DAMN UNCERTAIN ICE! MAYBE YOU'LL **DIE** SOON, AND IT'LL ALL BE YOUR **OWN** FAULT, SINCE YOU'RE THE ONE WHO JUST HAD TO GO AND GO ON THIS...

PILGRIMAGE

...WHERE'S THE MOON...

QUICKLY, YOU PULL YOUR SNOW PANTS ON, YOUR PARKA, YOUR ARCTIC MITTS... IT'S THE SAME ROUTINE EVERY TIME YOU STOP SKIING! YOU THINK ABOUT GETTING THE STOVE OUT SO YOU CAN MELT SOME SNOW AND HAVE A DRINK OF WATER!

AND YOU THINK OF HOW YOU CAME TO BE ON THIS GODDAMM ICE IN THE FIRST PLACE! YOU GOT THAT CALL FROM THE NEWSPAPER ...**OH,** HOW COCKY YOU WERE! "**SURE!**" YOU SAID, "I'LL DO A PIC- TURE OF GREY OWL'S CABIN!"

SHE WANTS ME TO DO ANOTHER DRAWING FOR THE "LANDSCAPE" FEATURE, SO I SAID I'D DO GREY OWL'S CABIN!

THAT'S NICE!

PARCHED BY THIRST, RACKED BY FATIGUE, YOU SKI ON; MILE AFTER MILE! AND ALL THE WHILE, THERE'S ONE THOUGHT RUNNING THROUGH THAT DEHYDRATED BRAIN OF YOURS:

THE WARDEN STATION!

IT'S ON THE SOUTH SHORE OF KINGSMERE LAKE! JUST GET TO THE END OF THIS ROAD AND A BIT FURTHER... YOU CAN MAKE IT! YOU CAN SPEND THE NIGHT THERE! SORT IT ALL OUT, AND THEN MAKE A **REAL** START!

LAKE

WASKES

82

THE STATION WILL BE EMPTY AND CLOSED, OF COURSE, BUT WITH YOUR BACKGROUND AS A FORMER TEENAGER, IT'LL BE NO PROBLEM TO JIMMY THE LOCK!

YEH, IT'S SURE GONNA BE NICE IN THAT WARDEN STATION! YOU'LL BE ABLE TO DRY YOUR CLOTHES BY A NICE WARM STOVE! THERE'LL BE A COT TO SLEEP ON! AND YOU'LL FIND, NO DOUBT, A STACK OF ANCIENT MAGAZINES TO READ!

MAYBE THIS WARDEN'S STATION WILL BE A REAL FANCY ONE WITH A BIG FIREPLACE! MAYBE THERE'LL BE A GROUP OF WOMEN SCIENTISTS THERE WHO WILL TAKE YOU IN, AND SHOW KINDNESS TO YOU!

THE FANTASIES THAT YOU CONCOCT TO KEEP YOURSELF GOING!
AS YOU SKI ALONG, A MAGNIFICENT PAIR OF MOOSE APPEAR ON THE SIDE OF THE ROAD AND KEEP ABREAST OF YOU FOR A WHILE! BUT YOU DON'T PAY MUCH ATTENTION TO THEM — YOU ARE ONLY INTERESTED IN MOVING DOWN THAT ROAD!

HE HAD A HELL OF A SECRET TO CARRY AROUND, SOMETHING THAT ALMOST NO-ONE KNEW ABOUT, EVEN WHEN HE WAS FAMOUS AROUND THE WORLD! "THE MODERN HIAWATHA", THE PRESS CALLED HIM...

WHAT BRINGS YOU TO ENGLAND, MR. GREY OWL?

I'VE COME TO SPEAK OF MY LAND: A GREAT, VAST, *WAR ZONE!*

IT IS THE LAST BATTLE-GROUND IN THE LONG DRAWN OUT BITTER CONTEST BE-TWEEN CIVILISATION AND THE FORCES OF NATURE!

AN ENGLISH NEWS-PAPER WROTE, "NOT SINCE MARK TWAIN CAME TO ENGLAND HAS THERE BEEN SO MUCH EXCITMENT OVER A LITERARY FIGURE FROM NORTH AMERICA"!

WELL, IT WAS A TIME WHEN MORE ART WAS PRODUCED OUTSIDE OF ESTABLISHED CULTURAL CENTERS! AND FOR PEOPLE LIVING IN THE BIG CITIES OF EUROPE, HE CAME FROM AN EXOTIC LOCALE!

THIS, ABOUT A GUY FROM *HERE*, FROM *NO-WHERESVILLE!*

DON'T FORGET IT WAS 1935, AND A "BACK TO THE LAND" MOVEMENT WAS UNDER WAY! PEOPLE WERE LOOKING FOR A PLACE TO GO TO ESCAPE THE ECONOMIC CATASTROPHE!

YEAH, COULD BE...

HEY, DID'JA EVER HEAR ABOUT HOW THE LECTURES OF GREY OWL WENT?

SIP

THEY'D ALWAYS START OFF WITH A SWAYING ORGANIST PLAYING "MOONLIGHT SONATA" AT THE SIDE OF A DARKENED STAGE! THEN, SUDDENLY, CLIPS FROM NEWSREELS WOULD BE THROWN UP ON A SCREEN! THE FILM WAS A COLLECTION OF QUICK CUTS-LIKE SOME KIND OF 1930's MTV VIDEO! THIS WAS 'CIVILISATION', FAMILIAR TO EVERYONE, EPITOMISED...

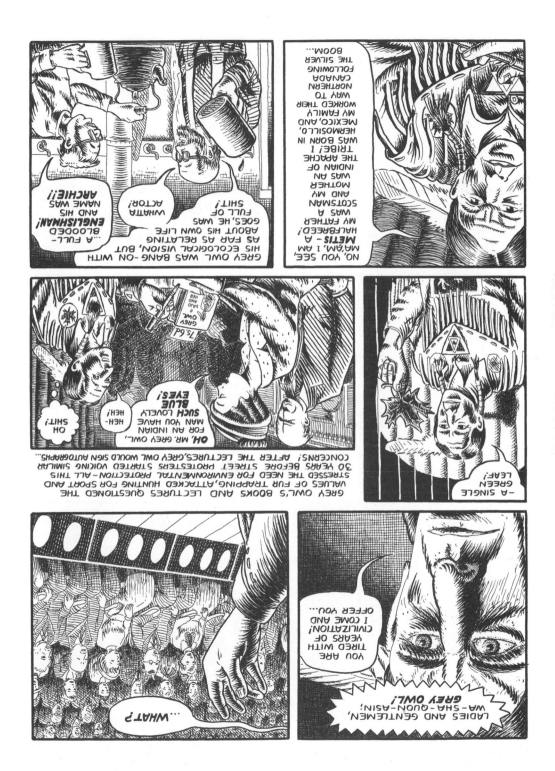

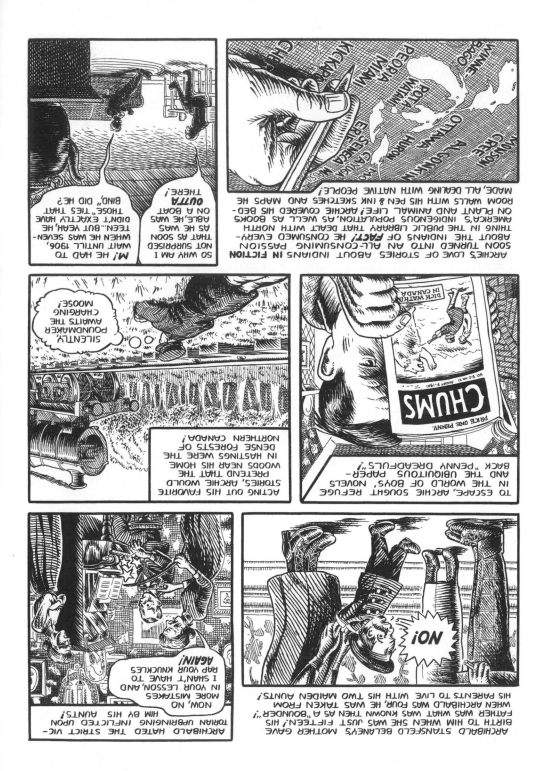

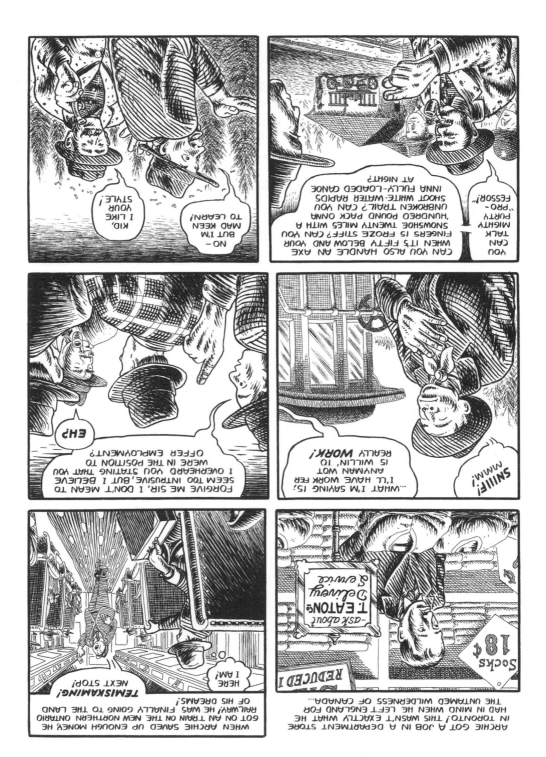

SHE WAS AN 19 YEAR-OLD WHO WORKED IN A LAKE TEMAGAMI LODGE! ANAHAREO WAS AN IROQUOIS WHOSE FAMILY ORIGINALLY CAME FROM OKA, QUEBEC!

SAY, DO YOU HAPPEN TO HAVE ANY *POTATOES?*

HA-HA! *NO!*

36 YEAR-OLD ARCHIE PURSUED ANAHAREO INTO THE WINTER!

HEY LISTEN! WHEN I GO BACK TO MY TRAPPING GROUNDS, WHY DON'T YOU COME WITH ME?!

I CAN'T! I-I MEAN I *WOULD*, BUT MY FATHER...

YEAH, I GUESS IT *WAS* A HARE-BRAINED IDEA... PUT IT DOWN TO WISHFUL THINKING! THE THING IS; WHEN A MAN IS ALONE IN THE BUSH AND GETS AN IDEA, THERE'S NEVER ANYONE AROUND TO LAUGH HIM OUT OF IT!

JUST NOW MY FRIEND SPOKE TO ME, AND HE TOLD ME THAT IF HE AND ANAHAREO CAN HAVE OUR BLESSING AND LOVE, IT WILL MAKE THEIR LIVES TOGETHER MORE HAPPY!

THEY ARE GOOD AND EVERYONE OF US LOVES THEM! NOW, TOGETHER, WE WILL PRAY TO GOD AND ASK HIM TO KEEP THE BLACK CLOUDS OF SICKNESS AND SORROW FROM THEIR TRAIL AND MAKE THEIR HEARTS AND THEIR SOULS SHINE WITH TRUTH AND HAPPINESS WHILE THEY ARE LIVING, AND AFTERWARDS, IN THE OTHER WORLD!

So BEFORE THE NEXT BIG FEAST, THE COMMUNITY LEADER, CHIEF PAPATI, GOT UP AND MADE THIS SPEECH:

AFTER MORE ARTICLES FOR _COUNTRY LIFE,_ ARCHIE WAS ASKED TO WRITE A BOOK! ALWAYS AN INTENSE GUY, HE THREW HIMSELF INTO EVERYTHING HE DID 100%!

HEY HONEY, GUESS WHA-!

JESUS H. CHRIST! HOW MANY TIMES MUST I TELL YOU NOT TO DISTURB ME WHILST I'M WORKING?!!

FOR ANAHAREO, A CABIN WITH ARCHIE WRITING IN IT WAS HELL MANIFESTED!

H-HE'S LIKE A **ZOMBIE!** LIVING WITH A WRITER IS WORSE THAN LIVING **ALONE!**

ANAHAREO'S SOLUTION WAS TO PURSUE HER **OWN** OBSESSION — GOLD PROSPECTING! SHE'D GO FAR NORTH, MANY TIMES, IN SEARCH OF THE ELUSIVE LUCRE!

GOOD-BYE!

"WHEN I FIRST SAW YOU, YOU WERE LIKE JESSE JAMES AND ROBIN HOOD ROLLED INTO ONE," ANAHAREO WOULD SAY... "BUT WHEN YOU'RE WRITING, IT'S LIKE YOU BECOME ONE OF YOUR CRABBY OLD AUNTS!"

SO THEN, IT'D JUST BE ARCHIE & JELLY ROLL ALONE, WITH ARCHIE'S WRITING AND ALSO, ARCHIE'S DRINKING PROBLEM, WHICH HE HAD PICKED UP IN HIS EARLY DAYS IN TEMAGAMI...

KERRY BROS VANILLA EXTRACT

IT WASN'T **SUPPOSED** TO HAP- PEN LIKE THIS! HADN'T SHE EN- COURAGED HIM TO WRITE?? HIS FIRST BOOK, "THE MEN OF THE LAST FRONTIER," WAS MET BY WIDE CRITICAL ACCLAIM, BUT WHAT DID IT MATTER WITH HER **GONE?!**

BUT HEY! SNAP OUT OF IT! THERE ARE PLANS AFOOT FOR YOU, MR. GREY OWL, **BIG** PLANS! THE FEDERAL GOVERNMENT IS LOOKING FOR SOME SORT OF TOURIST **DRAW** FOR ITS NEW NATIONAL PARKS IN THE WEST...

SIR, I'M IN AN POSITION TO OFFER YOU A POST WITH THE NATIONAL PARKS SERVICE WHERE YOU'LL BE ABLE TO FURTHER YOUR CONSERVATION WORK!

THE PARK WHERE GREY OWL ENDED UP LIES IN THE TRANSITION ZONE BETWEEN PRAIRE AND THE GREAT NORTHERN BOREAL FOREST! THERE, THIRTY MILES FROM THE CAMPS AND ACCESSIBLE ONLY BY WATER, A SPECIAL CABIN WAS BUILT FOR HIM!

PRINCE ALBERT NAT'L PARK
Saskatchewan R.
PRINCE ALBERT
SASKATOON

"...FAR ENOUGH AWAY TO GAIN SECLUSION YET WITHIN REACH OF THOSE WHOSE GENUINE INTEREST PROMPTS THEM TO MAKE THE TRIP...," WROTE GREY OWL, WHO, BEING A MASTER OF CANOECRAFT, COULD COVER THE DISTANCE IN HALF A DAY!

AND THE BEST FEATURE OF ALL WAS ANAHAREO! SHE WAS BACK!

THIS IS **EXCELLENT!** WE CAN GET STATIONS FROM **EVERYWHERE!**

...YOU'RE TUNED TO WBZ IN SPRING-FIELD!

GREY OWL'S CABIN WAS CON-NECTED TO THE LAKE BY A SINK HOLE, AROUND WHICH THE BEAVERS BUILT A LARGE NEST!

JELLY ROLL AND HER FAMILY ALSO ATTACHED A FOOD RAFT TO THE FRONT OF THE CABIN, MAKING, IN EFFECT, THE CABIN WALL A MERE DIV-EDER IN A HUGE **BEAVER LODGE!**

THE COUPLE WENT THROUGH FLYTOX BY THE **GALLON!**

SCRATCH SCRATCH
SCRATCH SCRATCH SCRATCH
SCRATCH SCRATCH

THE TAB WAS PICKED UP BY THE GOVERMENT...THE FLYTOX ...EVERYTHING ELSE! IT WAS THE PARK WARDENS WHO LUG-GED IT ALL UP TO THE CABIN!

Neilson's Crispy Crunch

50 POUNDS OF RICE... 40 LOAVES OF BREAD... 10 POUNDS OF PEANUTS, 5 BOXES OF APPLES AND ONE BOX OF CHOCO-LATE BARS...

AND **THAT'S** JUST TH' MONTHS FOOD FOR HIS ✦✦✦!! **BEAVERS!**

PELICAN BRAND

GREY OWL'S BOURGEOIS UP-BRINGING WITHIN THE BRITISH CLASS SYSTEM CAME OUT DURING HIS DEALINGS WITH THE WARDENS, WHOM HE TENDED TO TREAT AS **SERVANTS!**

I'M GLAD YOU CAME TODAY, THERE'S SOME **GARDENING** I WANT DONE!

GRADE APPL

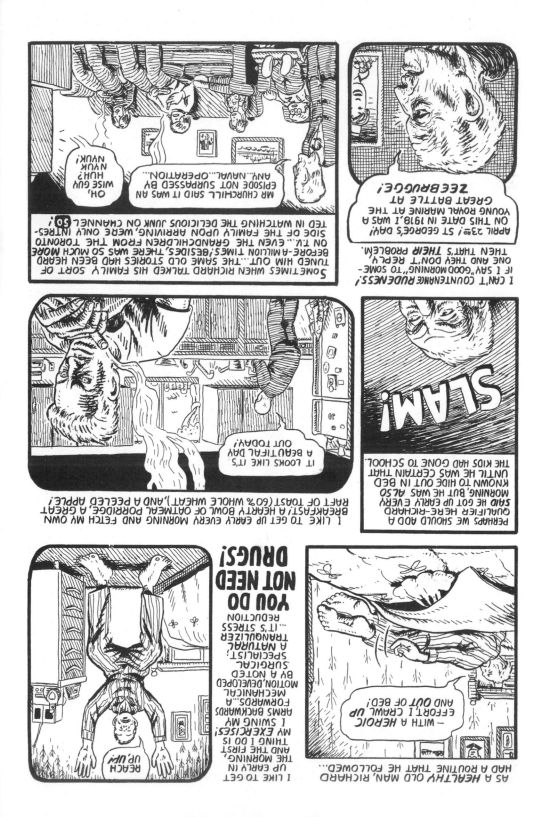

BUT RICHARD'S STORY IS IN SEARCH OF LOST TIME NOW... BACK TO WHEN THE UNIONS WERE *STILL* STRONG, WHEN THE PAY CHEQUE OF ONE WORKING MAN COULD SUPPORT ALL THESE PEOPLE!

RICHARD LIVED THE LAST HALF OF HIS LIFE WITH THE FAMILY OF HIS DAUGHTER AND SON-IN-LAW...

AND HE WORKS *HARD* YOU KNOW, IN AND OUT OF HIS TRUCK DELIVERING *HUNDREDS* OF CRATES OF MILK TO THE SUPERMARKETS – A *LOVELY* MAN!

OF COURSE, I NEVER SAY ANY-THING ABOUT IT, "MIND YOUR OWN BUSINESS," IS WHAT THEY'D TELL ME...

EVERY MORNING AT 1:30 I HEAR HUGH GETTING UP FOR WORK, COUGHING HIS LUNGS OUT, AND THEN THE NEXT THING THAT HE DOES IS LIGHT A CIGARETTE!

THERE'S HUGH AND MURIEL, DOWN IN THE BASEMENT SMOKING LIKE CHIMNEYS! HOW I *DETEST* SMOKING AND WHAT IT DOES TO PEOPLE!!

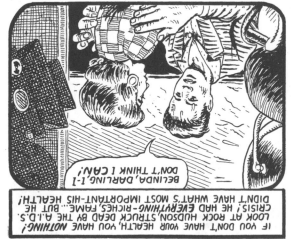

IF YOU DON'T HAVE YOUR HEALTH, YOU HAVE *NOTHING!* LOOK AT ROCK HUDSON, STRUCK DEAD BY THE A.I.D.S. CRISIS! HE HAD *EVERYTHING*–RICHES, FAME... BUT HE DIDN'T HAVE WHAT'S MOST IMPORTANT–HIS HEALTH!

BELINDA, DARLING, I–I DON'T THINK I CAN!

SO, TO GET HIS POINT ACROSS, HE'D GRAB YOU BY THE ELBOW AND REALLY *DIG* HIS FINGERS IN.

'ER THEN–I WANT YOU TO ALWAYS MIND YOUR *HEALTH!*

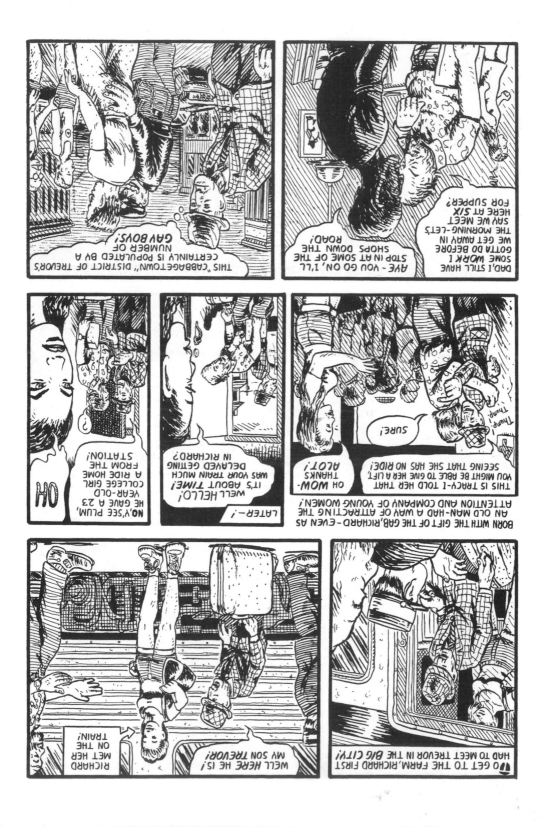

THE OLD SOLDIER TOOK RICHARD TO A COUNSELLOR WHO HAD A SPECIAL INTREST IN OLDER WORKERS!

THIS IS *TERRIFIC!* A MAN OF YOUR EXPERIENCE IS WHAT THEY'RE LOOKING FOR AT *GENERAL HOSPITAL!*

AND SO, AT AN AGE WHEN SOME PEOPLE BEGIN TO CONTEMPLATE *RETIREMENT*, RICHARD STARTED WORKING AS A HOSPITAL ORDERLY FOR $41°° PER WEEK!

HELLO "BORIS"!

TEE-HEE!

TALL, AND WITH THOSE DARK LOOKS... YOU'RE RIGHT HE *DOES* LOOK LIKE BORIS KARLOFF!

RICHARD HAD SETTLED IN *WINDSOR*--DETROIT'S CANADIAN COUSIN"! THIS WAS 1953, WHEN THE ENTIRE REGION WAS *BOOMING!*

...AND USUALLY, THE AIR WAS SO BAD IT MADE YOUR EYES WATER!

PRIDE OF THE LAKES

IT GOT TO BE A BIT SILLY, AT THAT HOSPITAL JOB, THE WAY THEY WOULDN'T LET ME RETIRE! AT AGE 65, THE BOARD OF GOVERNORS EXTENDED MY CONTRACT, AND THEY *KEPT ON* EXTENDING IT, YEAR AFTER YEAR, UNTIL I FINALLY HAD TO SAY *ENOUGH!!* I GUESS I HAD FOUND MY NICHE...A ROLE TO PLAY THAT NOBODY ELSE ON STAFF WANTED TO FILL...

ANYHOW, I REALLY *ENJOYED* ASSISTING THE DOCTORS AT THOSE AUTOPSIES...IT WASN'T DIFFICULT, WHAT WITH THE LITTLE POWER SAW I HAD TO WORK WITH...PEEL AWAY THE SKIN AND SCALP, SLICE OPEN, POP OUT BRAIN...I COULD DO IT IN MY *SLEEP!*

ONE DAY, SHORTLY AFTER PROHIBITION CAME INTO EFFECT IN 1919, AMERICA AWOKE WITH THE INCLINATION FOR EUROPEAN TRAVEL. PASSENGER LINERS, WHO FORMERLY FOCUSED ON PROMOTING ENDLESS NORTH AMERICAN OPPORTUNITIES AND BOUNTIES TO WOULD-BE OLD-WORLD EMIGRANTS, CHANGED DIRECTION!

BUSINESS BOOMERANGED AND *BOOMED* ON THE NORTH ATLANTIC! SCHOOL TEACHERS, STUDENTS, TOURISTS...THEY ALL SEEMED TO BE CRAVING THE SAME INEXPENSIVE "AUTHENTIC" EXPERIENCES; THE EXCUSE TO LOWER ONESELF INTO A BOHEMIAN LIFESTYLE PROVIDED THAT IT WAS ONLY FOR A LITTLE WHILE...

THE SHIP OWNERS WERE MORE THAN WILLING TO OBLIGE, CHANGING THE NOMENCLATURE OF THEIR "STEER-AGE" QUARTERS TO "THIRD CLASS TOURIST" IN ORDER TO ATTRACT THE NEW TRAVELER.

'NITE BUNKIES!

HEE-HEE!

EVERYBODY'S OVER THE SPEED LIMIT ON AN EVIL EASTBOUND STRETCH OF DEADLY ROAD!

IT'S NICE TO GET OUT OF THE CITY... WE CAN CHAT WITHOUT MY WORRYING ABOUT *DIS-TRACTING* YOU!

I'D HAD A FEW JOBS AFTER WORLD WAR ONE... I WAS A *POLICEMAN* IN AN AWFUL, TOUGH, COAL-MINING TOWN FOR HALF A YEAR, *AND* I WAS IN A LIVERPOOL SUGAR FACTORY TOO, BUT WORKING FOR THE CUNARD WHITE STAR LINE WAS THE *BEST!* THAT ONE "TRIP TO NEW YORK" OFFERED BY MAJOR EVANS ENDED UP LASTING *12 YEARS!*

ESTIC

I ALWAYS *LOVED* GOING INTO NEW YORK! THE PORT OF NEW YORK WAS *UNIQUE* OUT OF ALL THE WORLD'S BIG CITY HARBORS IN THAT IT WAS RIGHT IN THE *HEART* OF MANHATTAN, *NOT* OFF IN SOME OUTLYING DISTRICT... PASSENGERS COULD DISEMBARK, GET ON THE SUBWAY AND CHECK INTO A HOTEL WITHIN *MINUTES*..."BISMARCK"- A WAR PRIZE FROM GERMANY... CHANGED TO "MAJESTIC" I DID 3 TRIPS ON MAJESTIC, 5-6-35 TO 26-7-35... JOHN MAXTONE GRAHAM WROTE A BOOK ABOUT ALL THIS CALLED; THE ONLY WAY TO CROSS... YOU CAN CHECK IT OUT FROM YOUR LIBRARY!

MY RANK ABOARDSHIPS WAS EQUIVALENT TO A PETTY OFFICER. I ATE MY MEALS WITH THE CHIEF BARBER, LADY HAIRDRESSER, LAUNDRY MANAGERESS, GYM INSTRUCTOR AND THE SHIP'S POLICEMEN. WE WERE WAITED ON HAND AND FOOT!

AND YET RICHARD NEVER LOST TOUCH WITH THE COMMON MAN. THE INTRA-WAR THIRD CLASS PASSENGERS – ALSO KNOWN AS THE LEFT BANK CLASS – INFUSED IN MANY THE SPIRIT OF *LIBERAL IDEALISM!* IN LATER YEARS RICHARD WOULD BE AN ARDENT SUPPORTER OF CANADA'S SOCIALIST *N.D.P.!*

I GUESS I WAS SEEING "MAN AT HIS BEST." WORLD WAR TWO AND THE JOB IN THE AIRCRAFT FACTORY LOOMED NEAR, BUT AT THE TIME THE WORLD SEEMED A LIMITLESS PLACE... DURING THE WINTER, WHEN TRANS-ATLANTIC TRAFFIC SLACKENED SOMEWHAT, WE'D GO *CRUISING!* THE MEDITERRANEAN! OR, AFTER STOPPING IN NEW YORK TO PICK UP PASSENGERS, THE *CARIBBEAN!*

SO THE FOUR DAYS I'D SPEND EACH MONTH AT HOME IN LIVERPOOL WOULD BE A STUDY IN *CONTRASTS!* UNEMPLOYED MEN I'D SEE, PLAYING FOOTBALL IN SHIEL PARK, OR MEN JUST HANGING AROUND. IT WAS WHAT YOU CALL A *WORLD-WIDE* ECONOMIC *DEPRESSION!*

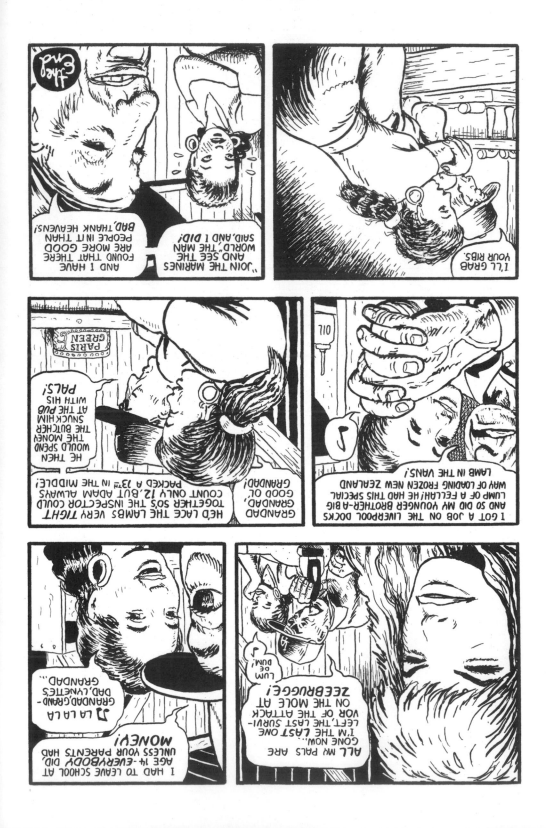

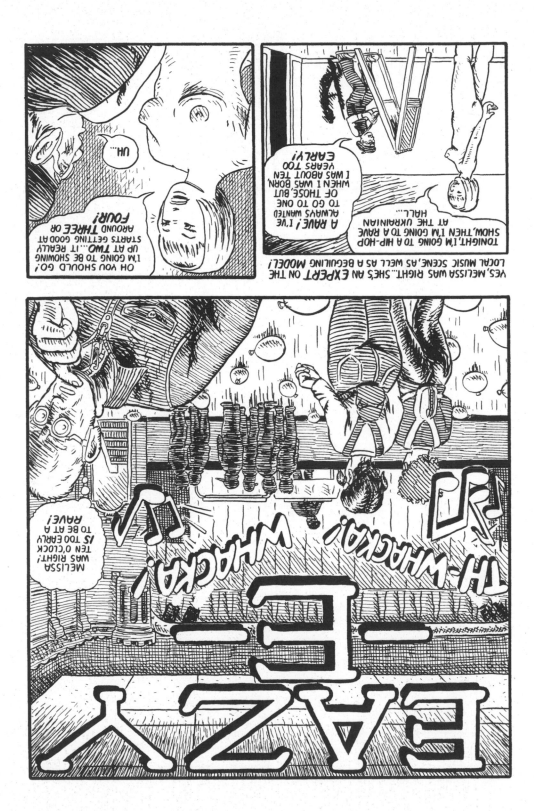

SHE WAS DESCRIBING HOURS THAT WERE CLOSER TO WHEN I GOT *UP!* SINCE I TURNED 30, I'D BEEN RISING EARLY TO DO MORNING *CALLISTHENICS!*

HI-UP HUP!

SAME ROUTINE AS IN THE OL' REGIMENT!

NOW, BACK IN TH' EARLY EIGHTIES THINGS WERE DIFFERENT... UP ALL NIGHT! DRUGS GALORE! IN FACT, IT WAS IN THE SUMMER OF 1982 THAT I FIRST TRIED WHAT I THOUGHT WAS A *NEW* DRUG...

...YOU *GOTTA* TRY IT, I JUST GOT IT FROM NEW YORK AN' IT'S A LOT OF FUN--IT'S CALLED *ECSTASY!*

OH WOW, THANKS A LOT ROSIE!

HMM...

I CAN REMEMBER FEELING A BIT *APPREHENSIVE...* A NEW DRUG I THOUGHT, WHO *KNOWS* WHAT IT'S EFFECTS MIGHT BE...BUT MY GIRLFRIEND WAS FEARLESS,' AND SO WE DROPPED IT RIGHT ON QUEEN STREET WEST, OUTSIDE OUR DOWNTOWN TORONTO APARTMENT...

AND TOOK A LONG SUBWAY AND BUS TRIP TO A SPRAWLING HANNA-BARBERA *THEME PARK* THAT HAD JUST OPENED UP OUTSIDE THE CITY!

THIS IS THAT "SPECIAL OCCASION" THAT WE'VE BEEN SAVING THESE *FREE* PASSES THAT YOUR MOTHER GAVE US FOR!

WONDERLAND

I LIKED THE DRUG - IT SEEMED TO OPEN DOORS OF PERCEPTION FOR ME. I WAS SEEING WHAT EVERYONE ELSE SAW-NO HALLUCINATIONS- BUT I FELT AS THOUGH I *UNDERSTOOD* BETTER AND QUICKER, WHAT I SAW!

THAT KID SHOULDN'T BE OUT THERE! DOESN'T ANYONE *SEE?!*

WAAA!

PUT PUT PUT

LABATT'S 50

WE CROSSED THE BARRIER AROUND THE MINI-CAR RIDE, AND BROUGHT THE CHILD TO SAFETY.

DON'T WORRY, IT'LL BE OK!

WE'LL HELP YOU FIND YOUR PARENTS!

∴SNIFF∴

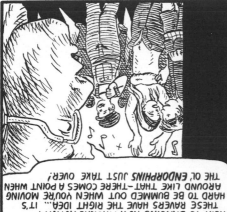

BUT EVEN WHEN DONE RIGHT, WALKING DOESN'T COMPARE NEXT TO *DANCING* AS A PHYSICAL ACTIVITY — THESE RAVERS HAVE THE RIGHT IDEA... IT'S HARD TO BE BUMMED OUT WHEN YOU'RE MOVING AROUND LIKE THAT—THERE COMES A POINT WHEN THE OL' *ENDORPHINS* JUST TAKE OVER!

LOOK OUT L'IL CAT!

JUST AS THE POOR CRAFTSMAN BLAMES HIS TOOLS, SO DOES THE POOR DRUG TRIPPER BLAME HIS SURROUNDINGS. BUT THE FACT IS, CHANGING SHADOWS FROM THE PASSING HEADLIGHTS WERE CAUSING DIFFICULTIES FOR ME IN THE WALKING DE-PARTMENT! PHANTOM CREATURES SCOOTED AT MY FEET...

THERE WAS THE SEWAGE TREATMENT PLANT, AN R. BUCKMINSTER FULLER DOME. IT WAS DARK DOWN THERE AND I SUPPOSE WE *COULD'VE* WALKED CLOSER TO IT. BUT I THOUGHT THE GROUND AROUND IT CRAPPY AND THERE WAS THE *INCLINE* IT WAS ON — A PROBLEM AT THE TIME...

BUT THERE WAS NO SUCH DEAL AROUND MY FRIEND'S HOUSE THAT NIGHT. EVERY ROAD SEEMED TO BE A MAJOR, FAST-MOVING ARTERY! EVEN THE MOST *BENIGN* ACID WOULDN'T'VE MADE IT ANY BETTER... WE WERE EXPOSED, NAKED IN THE GLARE OF THE ENDLESS STREAM OF LIGHTS!

IN RESIDENTIAL NEIGHBOURHOODS IN MANY CITIES, STREET PARKING IS PERMITTED. THE ROWS OF PARKED CARS ACT AS A SORT OF *BARRIER* FOR THE PEDESTRIAN, PROTECTING HER FROM TRAFFIC!

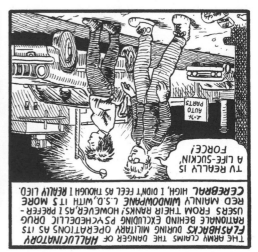

TV REALLY IS A LIFE-SUCKIN' FORCE!

THE ARMY CLAIMS THE DANGER OF *HALLUCINATORY FLASHBACKS* DURING MILITARY OPERATIONS AS ITS RATIONALE BEHIND EXCLUDING PSYCHEDELLIC DRUG USERS FROM THEIR RANKS! HOWEVER, AS I PREFER-RED MAINLY *WINDOWPANE* L.S.D., WITH ITS MORE *CEREBRAL* HIGH, I DIDN'T FEEL AS THOUGH I REALLY LIED.

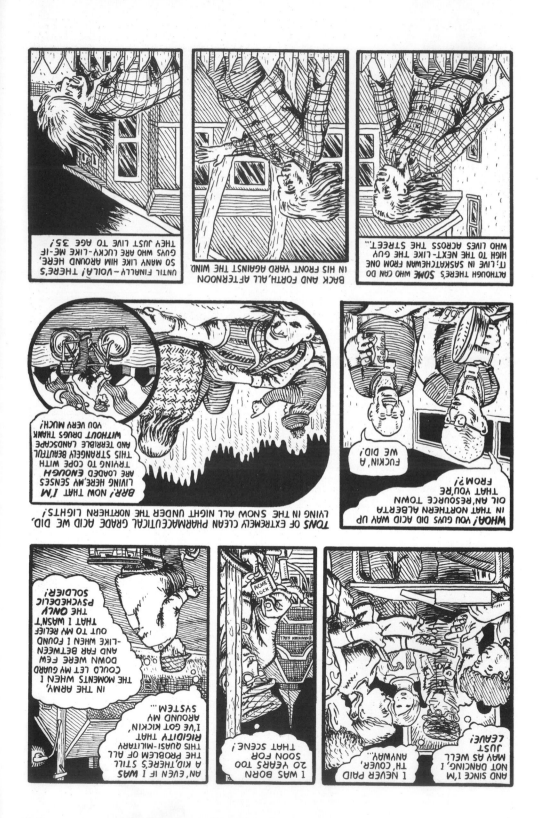

THE GUY WHO LIVES ACROSS THE STREET HAS A FRIEND IN THE HOUSE *BEHIND* ME WHOSE NAME IS *HAROLD!* BOTH THESE GUYS PASS THROUGH MY LOT WHEN THEY GO TO VISIT THE OTHER. ONE DAY, AS I SAT IN MY BACKYARD DRAWING IN A SKETCHBOOK, HAROLD SAW ME AND PAUSED.

UH-OH!

HEY!

I'M AN ARTIST TOO!

HE REACHED INTO HIS GREASY PANTS AND PULLED OUT A *KEYRING* OF THE RAWHIDE LEATHER AND BEADWORK TYPE...

HMM, THIS *IS* ART!

SOME NATIVE INTELLECTUALS THAT I KNOW WOULD CALL THIS "HOKEY INJUIN" STUFF, BUT *I* LIKE IT!

IT WAS A GOOD RELATIONSHIP FOR A WHILE... HAROLD HAD A CAPTIVE CUSTOMER, AND I HAD A SOURCE FOR INTRESTING AND "EXOTIC" PRESENTS FOR MY FRIENDS!

MY SISTER MADE THESE—

I COULD SEND THOSE EAR-RINGS TO ALINE IN *FRANCE*...

I'VE ALWAYS HAD A NAGGING FEELING THAT THIS WHOLE SITUATION IS SOMEWHAT *UNSTABLE* HOWEVER... HAROLD DRINKS A LOT OF BAD SUBSTANCES SUCH AS LYSOL AND RUBBING ALCOHOL. WORSE, HE'S STARTED A *NEW* THING; AGGRESSIVELY ASKING FOR MONEY EVEN THOUGH HE NEVER ANYMORE HAS ANYTHING TO SELL!

I NEED MONEY NOW!!

IN SASKATOON THERE'S ANOTHER WORLD FAR REMOVED FROM MINE, A WORLD OF *CULTURE* AND *IDEAS*... A *UNIVERSITY* COMPLETE WITH IVORY TOWER, LIES ALONG THE RIVERBANK. THIS IS WHERE *TIMOTHY LEARY* APPEARED LATE JANUARY IN 1994.

DO YOU PEOPLE IN SASKATCHEWAN REALIZE...

THAT THE TERM "*PSYCHEDELIC*" WAS COINED HERE?

Universitas Saskatchewanis

MCMVII

WE WERE ALL INVOLVED IN THE MOMENT; THOSE OF US ON THE BRIDGE; THE MEN IN THE WATER...WE WERE ALL WONDERING WHAT WAS GOING TO HAPPEN *NEXT!*

OUR CAPTAIN, OF COURSE, DID THE RIGHT THING HE —

NOW, DR OSMOND...

WOULD YOU *KNOW* THAT THIS WAS THE EFFECT OF THE DRUG? WOULD YOU *KNOW* THAT THIS WAS A HALLUCINATION?

OH, I KNEW IT WAS THE DRUG, I TOOK *GREAT PAINS* TO REMIND MYSELF OF IT...

OTHERWISE, THE THOUGHT OF THE PAST COMING OUT OF IT'S PLACE LIKE THAT WOULD'VE BEEN TOO MUCH TO *BEAR!*

AND SO INTO THE LONG AFTERNOON AND EARLY EVENING I SAW VARIOUS GEOMETRIC SHAPES AND INTENSE COLOURS...

"IS THERE A TREMENDOUS FEELING OF EXCITEMENT, DR. OSMOND?" "THERE'S TREMENDOUS FEELINGS OF EVERY SORT...THESE FEELINGS *IMPINGE* UPON YOU, LIKE THE WAVES OF A GREAT SEA! THERE ARE TIMES ONE FEELS ALMOST *WRECKED* IN THE POUNDING OF EMOTION!"

TO SUDDENLY FEEL IN THIS WAY *INVOLVED* WITH OTHER PEOPLE, INVOLVED WITH MANKIND, NORMALLY ONLY HAPPENS AT TIMES OF ENORMOUS EMOTIONAL IMPACT; IN MOMENTS OF EITHER *LOVE* OR *DEATH!*

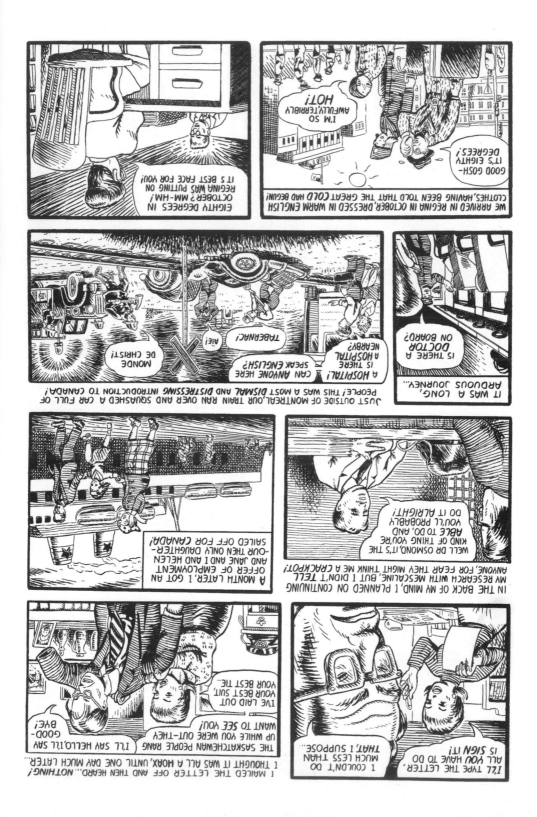

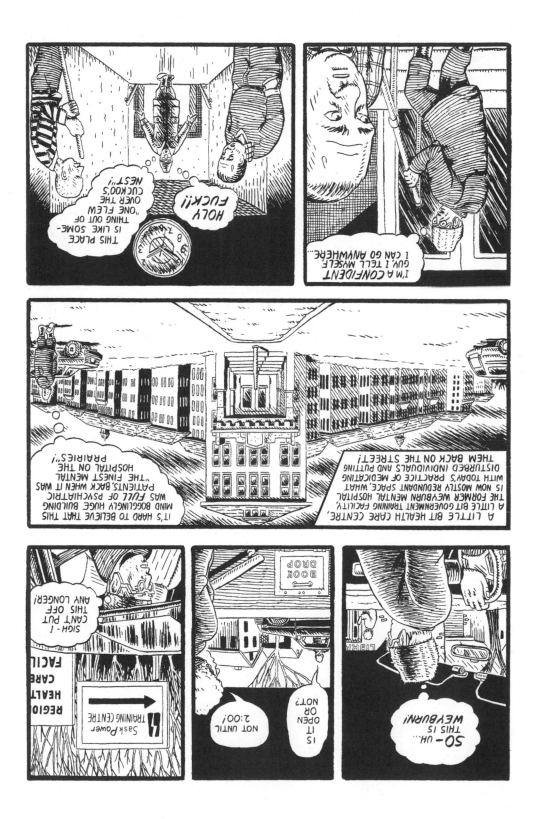

OR MAKE THAT "ONE FLEW OVER THE EMPTY...NEST"!

THERE'S A LOT OF SICK AND UNTREATED PEOPLE ON THE STREET BUT IN THIS HOSPITAL THERE'S HARDLY ANYONE!

THOUSANDS USED TO RESIDE HERE AND NOW THERE'S ONLY ONE HUNDRED AND SEVENTY-FIVE!

THE HOSPITAL WAS A DISGRACE IN 1953, A SNAKEPIT—THE REAL THING! THERE WERE PEOPLE LYING ON THE FLOOR. IT STANK. THERE WERE UNDERGROUND WALLS WITH STALAGMITIC AND STALACTITIC FECES...

THE CROWDING IN THESE WARDS IS INTOLERABLE! THERE'S NO REASON WHY WE CAN'T RELEASE SOME OF THE PATIENTS INTO THE COMMUNITY ON A LIMITED BASIS!

THE HOSPITAL HAD TO BE CLEANED UP, BUT MY OLD PRE-DECESSOR, THE OUTGOING SUPERINTENDANT WAS AGAINST ANY CHANGE! IT WAS DETERMINED THAT THE POLITICAL HEAT HAD TO BE APPLIED TO THIS ODD GENTLEMAN, BUT IT WAS THOUGHT BEST THAT I BE KEPT OUT OF THE WAY, SO AS NOT TO BE ASSOCIATED WITH THIS SO IT WAS ARRANGED THAT I WOULD ATTEND THE AMERICAN PSYCHIATRIC ASSOCIATION'S ANNUAL MEETING IN LOS ANGELES!

YES YES, THIS WAY DOCTOR OSMOND!

...AND WE MUST LOOK INTO OBTAINING L.S.D.-25 FOR OUR ALCOHOLIC PATIENTS!

WE WILL HAVE THAT DATA READY FOR YOU UPON YOUR RETURN FROM LOS ANGELES, DR. OSMOND!

AT THE SAME TIME, BY THE MOST EXTRAORDINARY COINCIDENCE, I RECEIVED A LETTER FROM ALDOUS HUXLEY! I HAD SENT HIM A COPY OF MY PAPER, "SCHIZOPHRENIA: A NEW APPROACH", IN WHICH I HAD PROPOSED THAT UNAFFLICTED PEOPLE, USING DRUGS, COULD GAIN A QUICK WINDOW INTO THE WORLD OF THE MENTALLY ILL. MR. HUXLEY RESPONDED ENTHUSIASTICALLY.

THE OPPORTUNITY TO STAY WITH ALDOUS HUXLEY AND HIS WIFE MARIA IN LOS ANGELES WAS TOO GOOD TO PASS UP. ALL THE SAME, I WAS APPREHENSIVE—MR. HUXLEY WAS, AT THE TIME, QUITE A PROTOTYPIC FIGURE!

...AND JANE! HE INVITED ME TO VISIT HIM IN LOS ANGELES!

ADDING TO MY ANXIETY WAS MR HUXLEY'S EAGERNESS TO EXPERIMENT ON HIMSELF, AND HIS REQUEST THAT I BRING HIM SOME *MESCALINE!*

OH NO— I WISH HE *WOULDN'T!*

GETTING THE STUFF ACROSS THE BORDER WASN'T MY CONCERN, IN FACT, I WAS WHOLLY IGNORANT OF CALIFORNIA'S LAWS!

THE PROBLEM IS, HE'S *BOUND* TO BE DISAPPOINTED IF HE TAKES THE MESCALINE AND *NOTHING HAPPENS!*

...AND WHAT OF THAT *OTHER* POSSIBILITY, WHAT IF HE TAKES THE MESCALINE AND IT GOES ON ALTOGETHER *TOO LONG!* SUPPOSING I GO DOWN IN HISTORY AS THE MAN WHO DROVE ALDOUS HUXLEY *MAD?!*

UNBEKNOWNST TO ME, THE LATE MRS. HUXLEY WAS *ALSO* HAVING HER *OWN* APPREHENSIONS!

YOU INVITED HIM TO *STAY?* WE *NEVER* HAVE PEOPLE TO STAY! EVEN WHEN YOUR BROTHER JULIAN COMES, WE PUT HIM UP AT THE WHITE TOWER!

AND WHAT IF HE HAS A *BEARD?*

WELL, THEN WE'LL ALWAYS BE *OUT!*

BUT MARIA HUXLEY WAS ONE OF THE MOST WARM AND KINDLY OF PEOPLE, AND SHE MANAGED TO LET MR HUXLEY AND I *GET TO KNOW EACH OTHER* WHICH IS VERY IMPORTANT!

ALL ENGLISHMEN ARE ODD, BUT THEY ARE ODD IN THE SAME WAYS!

THEN, ONE BEAUTIFUL DAY IN MAY!

WHOOSH!

HOLLYWOOD

Panel 1:

I'VE *HEARD* OF PRAIRIE COPS GOING AFTER JAYWALKERS LIKE THAT, BUT TO ACTUALLY *SEE* IT IN ACTION...

Panel 2:

I HANDLED IT PRETTY WELL MOSTLY, PROBABLY... THREE YEARS OF HAVING SHITHEADS IN THE ARMY YELL AT ME TAUGHT ME HOW TO PUT UP WITH MINDLESS AUTHORITY AND KEEP MY COO—

WHAT IS THE MATTER WITH THIS CAR?!

CLICK!

Panel 3:

WHY THOSE DIRTY—!! THEY STOLE MY BATTERY!!

Panel 4:

GODDAM! RIPPED OFF AGAIN!

OHH -OF ALL THE PLACES FOR STUPID, PETTY CRIME, SASKATOON IS THE *WORST!* IN *DETROIT* F'INSTANCE, YOUR CHANCES OF HAVING YOUR HOUSE ROBBED ARE ONE IN SEVEN HUNDRED... IN THE *HARDEST* DISTRICTS THERE, IT'S ONE IN SEVENTY...

THE CHANCES THAT YOU'LL HAVE A BREAK & ENTER PERPETRATED ON YOU IN SASKATOON ARE *ONE IN SEVEN!* WHERE *ARE* THOSE COPS, ANYWAYS??

AGGH!

Panel 5:

WHAT *IS* IT WITH THESE CRUMMY SASKATOON PEOPLE? YEARS AGO, AND ACROSS THE CONTINENT, I WAS IN WHAT I *THOUGHT* WAS A LONG-TERM RELATIONSHIP UNTIL-POF- A SASKATOON GUY TOOK MY PLACE!

THIS IS THE LAST OF MY STUFF EXCEPT FOR MY SUPERHERO COMIC BOOK COLLECTION WHICH I'M LEAVING FOR YOU TWO.

ALRITE!

Panel 6:

AND DIDN'T MY DEAR MOTHER HAVE EVERY LAST PENNY OF HER SAVINGS CLEANED OUT OF HER BANK ACCOUNT AND SPENT IN SOUTH AMERICA BY A COUPLE SHE *THOUGHT* WERE HER FRIENDS? AND WASN'T THE SCHEME MASTERMINDED BY A GUY FROM SASKATOON?

I-I DON'T *BELIEVE* THIS IS *HAPPENING* TO ME!

AND IT'S MY *BIRTHDAY!*

PLEASE WAIT HERE

Panel 7:

...I WON'T EVEN *MENTION* THE *OTHER* LONG RELATIONSHIP THAT ENDED WHEN MY WIFE HOOKED UP WITH A SASKATOON GUY WHILE I WAS AWAY 'CAUSE THAT WAS *IN* SASKATOON! MAN, THIS TOWN *FUELS* MY ANGER!

AH - WHAT AM I *DOING* COMPLAINING ABOUT THIS PLACE?

FIRST TIME I CAME HERE IT FELT AS THOUGH I WAS *MEANT* TO LIVE IN SASKATOON...

SPEERS FEED & SEED

IT'S NOT AS THOUGH THINGS WERE THAT *BAD* BACK EAST WHERE I GREW UP IN FACT, IT SEEMED AS IF THERE JOBS ONE *COULD ALMOST* LIVE WITH.

JUST ABOUT *EVERYONE* FROM THIS ANIMATION PROGRAM GETS JOBS-JOBS IN T.V. !

DIDYA SEE YEAH TALK FULL OF REFERENCES TO T.V. SHOWS I KNOW NOTHING ABOUT.

I STILL DON'T WATCH IT...

LUCKILY, I GOT MY TUITION BACK JUST BEFORE THE REFUND DEADLINE!

...AN ARMY TRAVELS ON ITS STOMACH, SO I'M HOPING THAT THIS LOAF OF BREAD-TURNED-PEANUT BUTTER AND JAM SANDWICHES WILL TAKE ME *FAR!*

WONDER

SO I TOOK OFF, ACROSS THE COUNTRY! I WAS ON MY OWN, THOUGH I *DID* MAKE A FRIEND ON THE TRAIN...

LOOK! A MOOSE!

VIA

WE GOT ALONG GREAT UNTIL I REVEALED MY BACKGROUND. IT'S WEIRD OUT WEST, I THOUGHT...

WOW! YOU'RE RIGHT! A MOOSE! *THAT'S* SOMETHING I'VE NOT SEEN BEFORE, GROWING UP AS I DID, DOWNTOWN IN THE HEART OF A *BIG, EAST-ERN CITY!!*

UGH!

I HAD A VAGUE NOTION OF VISITING A COUSIN IN EDMONTON, BUT INSTEAD I GOT OFF EARLY-AT *SASKATOON!*

WHITE PICKET FENCES, AMERICAN ELM TREES, SIMPLE WOOD HOUSES...

MAN, IT'S *TOO MUCH!*

-BUT AT THE EMPLOYMENT OFFICE...

THERE SEEMS TO BE SOME PROBLEM WITH FINDING *WORK* HERE-I'VE NEVER SEEN MEN LOOKING SO *HOPELESS!*

TO DAVID MILGAARD THE WHOLE THING—HIS ARREST, THE TRIAL—WOULD ALMOST BE *FUNNY* IF IT WASN'T SO *FUCKED UP!*

WHAT THE HELL RON WILSON, NICOLE JOHN AND SHORTY CADRAIN—HIS *FRIENDS!*—WERE UP TO, DAVID DIDN'T HAVE A *CLUE!* THEY WERE MAKING UP ALL THESE—THESE *LIES!* RON SAID DAVE WAS AWAY FROM THE GROUP FOR FIFTEEN MINUTES—WHEN IT WAS MORE LIKE FIFTEEN *SECONDS*—NICOLE SAID SHE SAW HIM *STABBING* SOMEONE, AND SHORTY WAS SAYING DAVE WAS A MEMBER OF THE *MAFIA!*

LOOK AT ME GUYS! LOOK... AT... ME!

AND THEN THERE WAS DAVID'S LAWYER CALVIN TALLIS—THE BEST COUNCIL LEGAL AID MONEY WOULD BUY!

THIS TRIAL IS *ENDING* AND I HAVE NOT SAID *ONE WORD* IN MY DEFENCE! HE ADVISED ME NOT TO TESTIFY, AND I *GUESS* HE KNOWS WHAT HE'S DOING...

ALL RISE!

...AND HOW DO YOU FIND THE DEFENDANT, GUILTY OR NOT GUILTY?

GUILTY.

DAVID'S MOTHER JOYCE HAD NEVER REALLY CONSIDERED THAT HER SON MIGHT BE FOUND GUILTY. SHE THOUGHT THAT HIS ARREST, THE TRIAL, WOULD MERELY THROW A *SCARE* INTO DAVID, TEACH HIM A *LESSON* ABOUT WHAT HAPPENS WHEN YOU HANG AROUND THE WRONG SORTS OF PEOPLE!

M-MOM? WILL YOU BRING ME SOME COMIC BOOKS?

THE CAR STAYS HOME!

A CAR HAS TO BE SAVED FOR *REAL* TRAVEL-TAKING IT OUT JUST ONCE A WEEK FOR GROCERIES KEEPS IT IN GOOD ENOUGH CONDITION FOR RUNS WITH ARTWORK TO SEATTLE PUBLISHERS. AND IF YOU'RE *LUCKY*, YOU CAN PAY YOUR WAY BY SELLING LANDSCAPE DRAWINGS TO "CANADA'S NATIONAL NEWSPAPER."

"WORKING OIL WELL IN THE BADLANDS OF ALBERTA."

DRAWING BY DAY, DRIVING BY NIGHT SOUNDS GOOD IN *THEORY*, BUT TOO MUCH OF IT AND YOU'RE SICK AND TIRED OF *SEEING!*

UH-IT'S SOMETIME AFTER *MIDNIGHT* AND I'M DOUBLE VISIONING! AM I GONNA *DIE* IN THIS MOUNTAIN PASS??

THAT'S WHEN YOU GRAB YOUR OWN PIECE OF HEAVEN BY ATTACHING A WATERPROOF TARP OFF THE BACK OF YOUR CAR AND STRETCHING OUT UNDER THE STARS.

AN AFFINITY FOR JOHN DENVER IS A SIGN OF A TYPE OF MENTAL ILLNESS I'M SURE, BUT THERE *HAS* BEEN TIMES WHEN I'VE KNOWN WHERE HE WAS COMING FROM WITH HIS "ROCKY MOUNTAIN HIGH"...

OVER THE MOUNTAINS FAR FROM HOME I'D GO, LOOKING, LEARNING BUT MAKING A MISTAKE EACH TIME IN ASSUMING THAT, AS I GREW, THINGS BACK HOME STAYED THE SAME.

UH-OH... SOMETHING'S *CHANGED* BACK HERE!

LIKE THE TIME I CAME HOME TO FIND MRS. ENG MOURNING FOR HER HUSBAND HARRY, WHO I'D NEVER MET, CONFINED AS HE WAS TO A NURSING HOME ALL THOSE YEARS. "GOOD HEART AND LUNGS, BAD LEGS," I WAS TOLD.

HARRY, HE *DIED!*

THIS IS A NICE NEIGH-BOURHOOD EVEN IF IT *IS* JUST A FEW BLOCKS FROM WHERE THE LAW IN THIS PROVINCE SAYS DAVID MILGAARD KILLED GAIL MILLER!

IT'S TOO BAD THAT I HAVE TO LEAVE, BUT WHAT CHOICE DO I HAVE? AFTER HARRY DIED, MRS ENG *SOLD* THE BUILDING TO A YOUNG, HUSTLING REAL ESTATE AGENT.

...WE'LL HAVE TO BUMP UP* THE RENT!

I'M BEING SQUEEZED OUT! OH WELL--I GOT ALMOST TEN YEARS OF PRODUCTIVITY IN HERE...

* FROM $300⁰⁰ TO $550⁰⁰/MONTH--THERE'S NO RENT CONTROL IN SASKATCHEWAN!

IT SEEMED SO *EGALITARIAN,* THE WAY RICH AND POOR LIVED SIDE BY SIDE HERE--HEY, THERE'S ANNA!

TO AND FROM THE FOOD BANK WITHOUT A HAT OR MITTENS, HER COAT UNDONE! DOES SHE NOT *FEEL* COLD?

...RIGHT NEXT DOOR TO POVERTY-STRICKEN OL' ME LIVES A REASONABLY WELL-OFF *JUDGE!*

G'DAY IRENE! HEY, I WAS JUST THINKING ABOUT A LEGAL THING, ABOUT DAVID MILGAARD AND HOW A LOT OF PEOPLE SAY HE WAS *FRAMED!* THAT HIS CASE WAS COVERED UP BY SASKATCHEWAN'S LEGAL AND POLITICAL ESTABLISHMENT!

I'M NOT FAMILIAR WITH ALL THE DETAILS OF THAT CASE, BUT MY BROTHER-IN-LAW WAS *DEPUTY POLICE CHIEF* WHEN MILGAARD WAS ARRESTED!

AND *HE* SAYS THAT THE NEW EVIDENCE *MIGHT* CLEAR HIM OF *RAPE* BUT HE'S STILL GUILTY OF *MURDERING* THAT POOR GIRL!

BUT...BUT...

IN PRISON, PERMANENTLY DISABLED AS A RESULT OF THE POLICE SHOTGUN BLAST, DAVID WAS PRESCRIBED *LITHIUM* IN AN EFFORT TO TREAT HIS SEVERE *DEPRESSION.*

AIRPLANE COMIN' IN FOR A LANDIN'!

WOO!

HAVE A NICE DAY

AROUND THIS TIME, DAVID'S MOTHER JOYCE, BEGAN IN EARNEST HER TIRELESS CAMPAIGN TO FREE HER SON. THE START OF EACH DAY SAW HER AT FIVE IN HER BASEMENT OFFICE!

...THE ONLY WAY WE'RE GOING TO GET HIM OUT IS BY FINDING THE *REAL KILLER!*

SUCH ACTIONS THREATENED THE LEGAL ESTABLISHMENT. CHIEF CROWN PROSECUTOR SERGE KUJAWA'S REACTION WAS *TYPICAL...*

MILGAARD HAS BEEN *INSANE* ALL HIS LIFE AND EVERYONE KNOWS IT!

WITH EVERY LAST BIT OF HER RETIREMENT SAVINGS, JOYCE MILGAARD HIRED WINNIPEG LAWYER HERSH WOLCH. IN FEBRUARY, 1990, HE GOT THIS TIP—

DO YOU WANT TO KNOW WHO KILLED GAIL MILLER?

SURE!

CHECK OUT *LARRY FISHER* —ASK HIS *WIFE!*

LARRY FISHER WAS DAVID MILGAARD'S EXACT OPPOSITE. HE WAS A CLEAN CUT, POLITE, HARD-WORKING CONSTRUCTION WORKER WITH A WIFE AND DAUGHTER, THE TYPE OF MAN THE POLICE-IF NOT THE MAJORITY OF PEOPLE IN THE PROVINCE-COULD RELATE TO.

Linda and Larry Fisher on their wedding day in 1967.

BUT THERE WAS *ANOTHER* SIDE TO HIM.

H'LO!

HE WAS A RAPIST OF THE VILEST, MOST VIOLENT, KIND.

DO AS I *SAY!*

FISHER WAS A LITTLE MAN WITH POWERFUL ARMS AND SHOULDERS. HIS VICTIMS TENDED TO BE WOMEN IN NURSING OR HOSPITAL-LOOKING UNIFORMS. FISHER'S *MOTHER* ALSO WORKED IN A HOSPITAL. SHE WORE A WHITE UNIFORM TO HER JOB IN THE HOSPITAL'S KITCHEN.

A PUNISHMENT-TYPE RAPIST LIKE FISHER IS ABNORMAL, EVEN FOR A SEXUAL ASSAILANT. DURING ONE ATTACK, FISHER INSERTED A *KNIFE* INTO HIS VICTIM'S VAGINA.

ANOTHER TIME, HE BIT A WOMAN ON THE NIPPLE WITH SUCH FORCE AS TO ALMOST COMPLETELY *SEVER* IT.

FISHER RAPED WOMEN IN CITIES ACROSS THE PRAIRIES. HE WAS CAUGHT WITH HIS PANTS DOWN IN WINNIPEG. IN SASKAT-OON, THE SITES OF THE ATTACKS HE PLEADED GUILTY TO IN 1971 AND THE LOCATION THAT GAIL MILLER'S BODY WAS FOUND IN.

5 DURING DAVID MILGAARD'S TRIAL, THE RAPIST FISHER WAS INACTIVE. ON FEB. 21ST, 1970, THREE WEEKS AFTER MILGAARD'S SENTENCING, FISHER RAPED AN 18-YEAR-OLD WOMAN 6 BLOCKS FROM HIS HOUSE.

4 20-YEAR-OLD GAIL MILLER WAS RAPED AND KILLED 2 BLOCKS FROM FISHER'S HOUSE ON JAN. 31ST, 1969.

3 FISHER WAS DOING CONSTRUCTION WORK AT THE UNIVERSITY OF SASKAT-CHEWAN WHEN HE INDECENTLY ASSAULTED A 19-YEAR-OLD STUDENT THERE.

FISHER LIVED AT 334 AVENUE O.

SASKATOON

South Saskatchewan River

Temperance Street

1 ON OCT. 21ST, 1968, LESS THAN 7 BLOCKS FROM HIS HOME, FISHER RAPED A WOMAN IN HER EARLY 20S.

2 ON NOV. 13TH, 1968, FISHER RAPED A WOMAN 10 BLOCKS FROM HIS HOUSE.

AFTER A MAP BY BERNARD BENNELL

IN PRISON, FISHER RECEIVED NO TREATMENT FOR HIS PROBLEM. LET OUT IN 1980, THE FIRST THING HE DID WAS GRAB A 56-YEAR-OLD WOMAN.

FISHER DRAGGED HER TO AN ABANDONED HOUSE WHERE HE RAPED HER, STABBED HER THREE TIMES, TRIED TO SUFFOCATE HER, SLIT HER THROAT FROM EAR TO EAR AND LEFT HER FOR *DEAD*.

ARGUH—

HOW WOULD YOU LIKE IT IF SOMEONE DID THIS TO YOUR *MOTHER?*

LEAVE MY MOTHER OUT OF THIS.

OK, THE CAR DAVID MILGAARD WAS IN GOT STUCK AROUND HERE, NEAR THE PLEASANT HILL SCHOOL! —I'LL SEE HOW LONG IT TAKES TO GET TO THE MURDER SITE!

THE CONVICTION OF DAVID MILGAARD HINGED ON THE STATEMENT NICOLE JOHN GAVE TO POLICE UNDER DURESS AND RON WILSON'S TESTIMONY IN COURT.

DAVE CALLED THE WOMAN THAT WE ASKED DIRECTIONS FROM "STUPID BITCH" AND THEN LATER, HE *STABBED* HER WITH HIS RIGHT HAND! CAN I GO NOW?

...SO THE CAR WAS STUCK AND I TURNED 'ROUND TO LOOK FOR DAVE AND HE WAS *GONE* AND I DIDN'T SEE HIM AGAIN FOR *FIFTEEN* MINUTES!

AT THE PRELIMINARY TRIAL YOU SAID *FIVE* MINUTES.

YEAH, WELL I THOUGHT ABOUT IT A LOT SINCE THE PRELIMINARY...

I STILL HAVEN'T GOTTEN TO WHERE GAIL MILLER'S BODY WAS FOUND! THEY SAID MILGAARD WENT FROM WHERE THE CAR WAS STUCK, FOUND GAIL MILLER, RAPED HER IN THE MINUS FORTY TWO DEGREE COLD AND GOT BACK IN UNDER FIFTEEN MINUTES!

DIDN'T *ANYONE* AT THAT TRIAL TRY COVERING THIS DISTANCE? OR IS IT *TOO SIMPLE*??

THE WALK LIGHT TO CROSS 20ᵗʰ ST. IS NOW ON!

MAN, IT'S A *LONG* WAY FROM TH' PLEASANT HILL SCHOOL!

IN RESPONSE TO A FLYER CIRCU-LATED BY JOYCE MILGAARD IN 1980, LINDA FISHER TOLD POLICE OF HER SUSPICIONS ABOUT HER EX-HUSBAND LARRY. THEY ALL BUT *IGNORED* HER.

HE *NEVER* MISSED WORK...

BUT ON THE MORNING OF THE MURDER HE *DID!*

THE SASKATOON POLICE NEVER TOLD MILGAARD'S LAWYERS ABOUT FISHER! IN FACT, THEY NEVER PUBLICIZED FISHER'S ARREST *AT ALL!* SOME OF HIS RAPE VICTIMS LIVED IN *FEAR* FOR *TWENTY YEARS* BEFORE THEY FOUND OUT THAT FISHER HAD LONG AGO BEEN CAUGHT.

LINDA RECALLED AN ARGU-MENT TAKING PLACE ON THE MORNING OF THE MURDER...

...AND I BET IT WAS *YOU* THAT KILLED THAT GIRL, HAH! WASN'T IT? ONE OF MY *KNIVES* IS MISSING!

"I FELT *BAD* FOR SAYING THAT. HE TURNED PALE AND ACTED ALL SHOCKED AND SCARED."

MAYBE THE SASKATOON POLICE DIDN'T WANT TO ADMIT THAT LARRY FISHER *COULD'VE* BEEN GAIL MILLER'S KILLER, BECAUSE THE IMPLICATION OF MILGAARD'S INNOCENCE WAS FAR TOO SICKENING TO CONTEMPLATE.

BUT EVEN A PERSON WHO WAS *DEAD CERTAIN* THAT JUSTICE HAD BEEN CORRECTLY SERVED HAD TO ADMIT *IT WAS AN AMAZING COINCIDENCE...*

THE WAY THE TRAIL FROM THE SCENE OF GAIL MILLER'S MURDER LED TO THE HOUSE AT 334 AVENUE O.

THE WAY DAVID MILGAARD AND HIS FRIENDS WENT TO THAT HOUSE TO PICK UP SHORTY CADRAIN ON THE MORNING OF GAIL MILLER'S MURDER.

AND THE FACT THAT IN THE VERY SAME HOUSE, LARRY FISHER LIVED IN THE *BASEMENT SUITE!!*

HEY SHORTY! OPEN UP! IT'S *FREEZING* OUT HERE!

BANG! BANG! 334

...AND I BET IT WAS *YOU* THAT KILLED THAT GIRL!

DAVID MILGAARD WAS CANADA'S LONGEST SERVING PRISONER WHEN HE LEARNED ABOUT THE NEW DNA TESTING TECHNOLOGY.

I *WANT* THAT!

CAN'T SIT DOWN FOR VERY LONG DUE TO THE SHOTGUN BLAST IN THE ASS.

THE DNA TESTING CLEARED DAVID MILGAARD AND IMPLICATED LARRY FISHER. IN THE SUMMER OF 1999, THE SASKATCHEWAN GOVERNMENT AWARDED MILGAARD TEN MILLION DOLLARS IN COMPENSATION.

The StarPhoenix

Vindicated
DNA test exonerates Milgaard

...AND PEOPLE IN SASKATCHEWAN CONTINUE TO STRUGGLE TO UNDER-STAND THE WHOLE SORDID MESS.

...I GREW UP NEXT DOOR TO LARRY FISHER IN NORTH BATTLEFORD! HE *ALWAYS* HAD GIRLFRIENDS OR HE WAS MARRIED!

I DON'T KNOW WHY HE HAD TO DO THAT TO ALL THOSE WOMEN!